Phaidon Press Limited
140 Kensington Church Street
London W8 4BN

First published in Great Britain 1992

© Parramón Ediciones, S.A. 1991

ISBN 0 7148 2815 7

A CIP catalogue record for this book is
available from the British Library

Printed in Spain

Learn to draw with

Wax
Crayons

Materials, skills and
step-by-step projects

Wax crayons

Learning to use wax crayons

This book has been designed to help you learn how to draw with wax crayons. It tells you about the materials you need and explains the various skills used to create different effects with wax crayons. Start by reading about the basic skills, then follow the step-by-step projects later in the book to practise what you've learned.

This book is divided into three parts: the first part tells you about the materials you need; the second part explains the skills for using wax crayons; the third part contains step-by-step projects to follow.

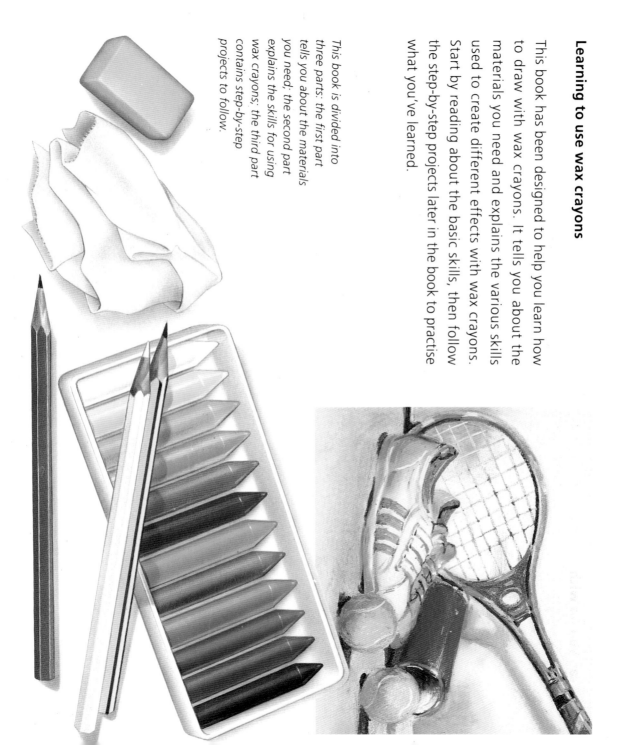

Why use them?

What can you do with wax crayons?

Wax crayons are opaque and therefore can easily cover the background.

They are made of wax, which melts when heated. The heat from your hand is enough to soften them.

Wax crayons can be used in the following ways:

○ You can apply them directly as though they were ordinary crayons with a very thick, soft lead

○ You can cover one colour with another

○ You can mix them on a drawing and melt them with the heat and pressure of your fingers

Wax crayons are opaque

Wax crayons can be used on top of each other

Wax crayons can be mixed

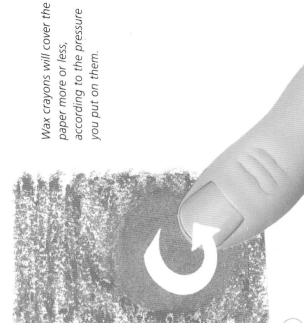

Wax crayons will cover the paper more or less, according to the pressure you put on them.

What are wax crayons?

How are wax crayons made?

Wax crayons are made with pigments (coloured matter) and wax.

Every manufacturer has a secret formula, which is why not all wax crayons are the same. Some are pastier then others, which makes them melt more easily, but there are no great differences.

All wax crayons are good tools for learning drawing and painting.

The 12 most used colours

Boxes with 12 colours usually contain the following:

1	White	7	Light green
2	Light yellow	8	Dark green
3	Dark yellow	9	Light blue
4	Yellow ochre	10	Dark blue
5	Red	11	Brown
6	Purple	12	Black

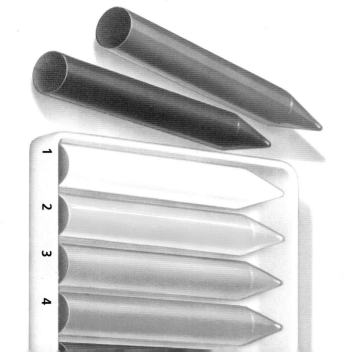

A 12-colour box provides all the colours you need. You could work with only the three primary colours, which you can read about on page 18. To begin with, use the range of shades you have in your 12-colour box.

How to choose them

Choosing colours

A box with many different colours provides a wide range of shades of the same colour: various yellows, different greens, a variety of blues and so on.

But you do not need a wide variety of colours.

As you will see on pages 18 and 19, only three colours are really essential - yellow, blue and red.

Using only these six colours and white you can draw any subject.

Light yellow

Light blue

Purple

Red

Light green

Light brown

7

6 7 8 9 10 11 12

What to draw on

Choosing the right paper

To get the best results you need to choose the right paper for wax crayons.

Smooth, glossy papers don't work because wax doesn't stick to them. The best paper to draw on with wax crayons is either fine-or medium-grain paper. There are also coloured papers.

You should not use very coarse-grain paper because you would waste your colours and get no useful results.

Both white and coloured paper can be bought in single sheets as well as in pads from art shops.

Coloured paper is suitable for drawing with wax crayons. Some of the available colours are shown below.

Other papers

Card and board

As well as paper, there are many other surfaces you can draw on with wax crayons. They stick easily to many kinds of cardboard, provided they are not glossy. Collect a variety of different types of cardboard and experiment with them.

A wooden board provides a firm surface to work on. If you prefer working on a white background, you could paint you board with one or two layers of matt (non-glossy) white paint.

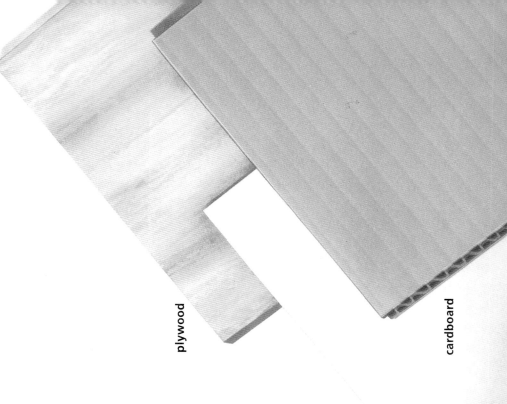

plywood

cardboard

paste board

The most suitable papers for wax-crayon drawing also come in pads of different sizes and qualities.

Other tools & materials

Collecting the basic materials

Before starting to draw with wax crayons you will need to collect together various other materials:

- A 45 x 60-cm wooden drawing board to hold the paper and make working comfortable

- Metal spring clips to fasten small papers to the board

- Drawing pins to fasten large papers to the board

- A cutter for removing excess colour

- A rubber

- Pencils: to prepare drawings use a soft graphite pencil on white paper, and a white pencil on coloured paper

- A rag to clean your crayons

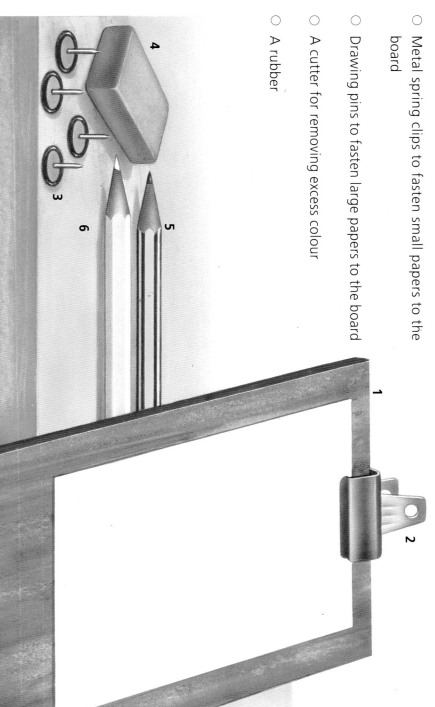

Useful tips

Scraping off colour

Once you apply wax crayons, their colours cannot be completely rubbed out. The only thing you can do is scrape them off with a cutter. You can also use the cutter to make sgraffito - by scratching through the crayon you can expose the white surface underneath. Also, by gently scraping with the cutter you can remove any excessive build up of crayon.

Other hard tools can be used for this, for instance the lid of a ball-point pen, a toothpick, a craft knife, a single-edged razor blade and so on.

When you fasten the paper with drawing pins, avoid damaging it by putting a piece of cardboard between the drawing pin and the paper.

Wax crayons quickly become dirty when you apply one colour to another.

1 **Drawing board**
2 **Metal spring clips**
3 **Drawing pins**
4 **Rubber**
5 **Soft graphite pencil**
6 **White pencil**
7 **Rag**

A **Toothpick**
B **Ballpoint penlid**
C **Paintbrush handle**

Drawing skills

Starting to draw

Now you can start practising drawing with wax crayons. First, you need to master the basic method of applying colour directly with the crayons.

This method differs from drawing with ordinary crayons. When you press hard with a wax crayon, you make compact, brilliant marks. These are difficult to achieve with ordinary crayons.

1 With a pencil, draw a rectangle about 4 x 12 cm. Colour a third of it blue with light strokes. Colour the last third with heavy strokes. The middle area should be coloured with medium pressure.

2 Repeat the same process, this time applying yellow on top of the blue. This will create three different values of green.

1

2

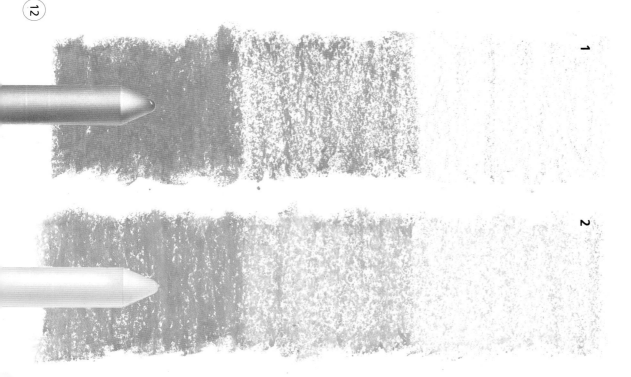

Drawing skills

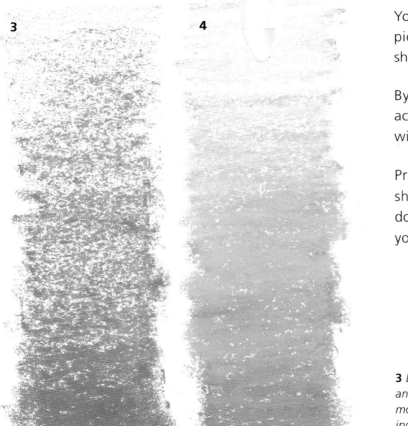

You will find that you can create bold, strong pictures with wax crayons, but that it is difficult to show tiny details with them.

By varying the pressure on the paper, you can achieve four different results (or qualities) working with just one or two colours.

Practise on a medium-grain paper. Try the skills shown on the following pages. Don't worry if you don't get them right first time. Keep practising until you get the results you want.

3 *Draw another rectangle and fill it in with red. Apply more and more pressure, increasing the pressure on the crayon as you approach the bottom.*

4 *This method is more difficult. Apply white crayon on top of the red, keeping the same change in value overall. This will produce tones ranging from pale pink to intense red.*

Drawing skills

Mixing colours

Artists create many colours by mixing two or more colours together.

With wax crayons, mixing is done mainly by adding layers of colours. You can use either light strokes or heavy strokes of one colour on another depending on the effect you want to achieve. To begin with, simply apply colour with varying degrees of pressure.

If you make light strokes, the effect will largely depend on the paper grain. Coarse-grain white or coloured papers show through the layers of crayon.

If you control the pressure of the strokes, you will see how the colours mix to form a single 'paste' of colour. Medium-grain papers give the best results.

With light strokes, colour a green background on fine-grain paper. Apply red with light strokes to this background. Try to create an even brown from this mixture.

Repeat the process on a coarser paper. Look at the effect produced by the little white dots (the valleys in the paper) that have not been covered by colour.

Try to achieve this mixture using pressure. Apply red on a blue background, pressing the second colour on to the first one and mixing them

When you put two or three colours on top of each other using pressure, you can mix them. Mixing more than three colours is very difficult.

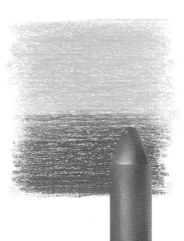
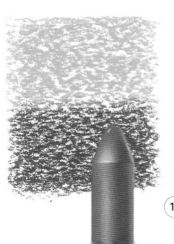
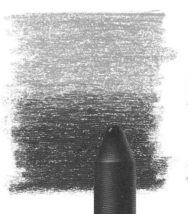

Making mistakes

When applying and mixing colours, you can make mistakes. When this happens, the only thing you can do is scratch the wax with a cutter and then use a rubber. It becomes more difficult with coarse-grain paper as the cutter can easily damage the surface of the paper.

However, if you scratch lightly and then use a rubber you will create an area on which new colour will stick easily, hiding the previous colour you didn't like.

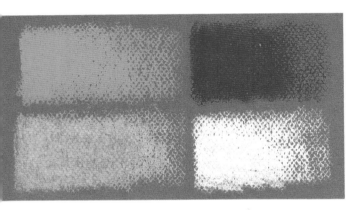

Drawing on coloured paper

When you work on coloured paper, light strokes produce a different effect, since your eyes mix the colour of the crayon with the paper underneath, which is not completely hidden.

The coarser the paper, the more important its colour will be in the final result. If you don't want the paper colour to affect the final colour, apply wax with enough pressure to fill in the little valleys, so you completely hide the paper colour.

Colour a small area. Remove the wax layer by scratching with the cutter. Use a rubber to remove more colour.

Wax crayons cannot be completely rubbed out.

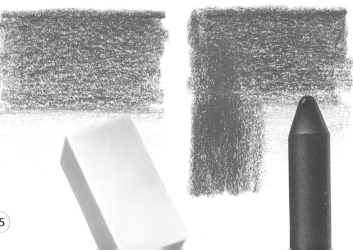

Drawing skills

Using impasto

Impasto is a way of using the pasty quality wax gains when it is rubbed with the fingers.

Here are some examples of the effects achieved by means of impasto.

When you rub and press with a finger on two combined colours, they should melt and mix perfectly.

You will need to practise to master impasto, but it is worth the effort because it is one of the most important methods of wax crayon drawing.

On the right are two examples of impasto. In the first (a sphere), two colours have been blended. In the second example (a cylinder), impasto has been used to blend layered colours, shading in the darker colour on top of the lighter one.

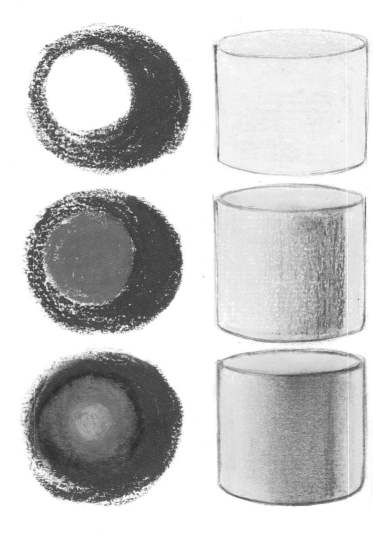

Impasto of two colours next to each other

Impasto of two colours on top of each other

Using sgraffito

Sgraffito involves removing colour by scraping with a blade or other pointed tool to expose the colour or surface underneath.

This method is very useful when you want to define shapes, highlight details, achieve transparency and retrieve colours that have been covered over.

There are some examples on this page. Try doing some sgraffito work of your own.

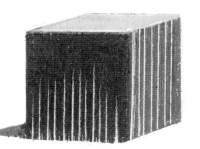

Examples of sgraffito technique

Sgraffito applied to the sides of this cube makes them stand out.

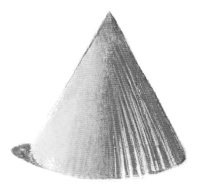

Sgraffito applied to this cone makes it look as though it is polished.

Apply a red layer on a yellow background.

Try practising with the cap of a ballpoint pen.

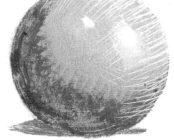

On this sphere, sgraffito stresses the brightness of the lit area. This helps to emphasize its shape.

Drawing skills

Discovering primary colours

The basic colours are blue, red and yellow.

They are called the *primary colours,* because they are the basis of all the colours found in nature. Mix them in pairs and you will create purple, orange and green, the *secondary colours.*

Tertiary colours are created by mixing together primary and secondary colours. Red + orange = red-orange; blue + green = blue-green, etc. Try them in any combination, using varied strokes and pressure.

Mixing colours

For most of your work, the colours you have in your box will be enough. You can use them either directly or by mixing them as you like.

Practise rubbing or making impastoes of colours - especially the primary colours - with your fingers. Try using just light blue, red and yellow together.

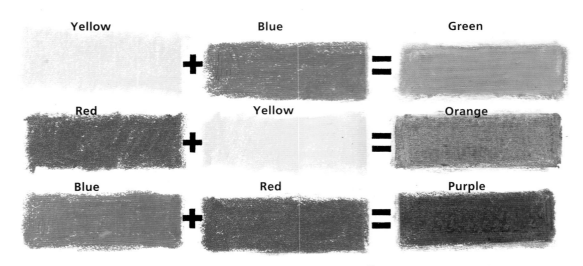

Yellow	Blue	Green
Red	Yellow	Orange
Blue	Red	Purple

The colour wheel

The colour wheel (or chromatic circle) is a ring of twelve colours, consisting of the three primary, the three secondary and the six tertiary colours.

The colour wheel shows arrows that link opposite colours: these are the *complementary colours*. Orange, for example, is complementary to blue, and yellow is complementary to purple.

Intense contrasts are achieved when you use two complementary colours side by side.

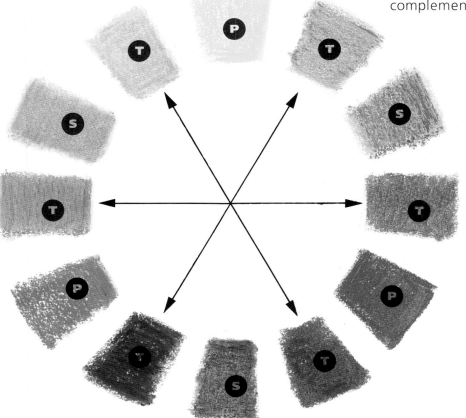

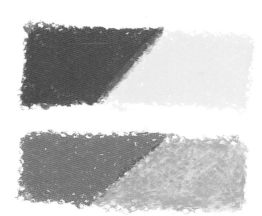

First projects

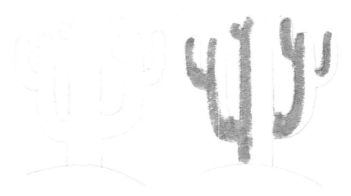

Draw the outline of this simple flower.

Apply the first layer of colour, pressing the crayon lightly and keeping it slightly slanted.

While continuing to practise this simple skill, start doing impasto. Draw the shape of the cactus.

Colour the shadowed areas, pressing the crayon on the paper, but being careful not to go over the pencil lines.

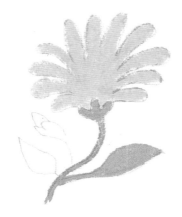
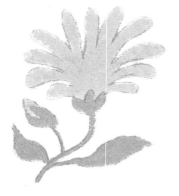
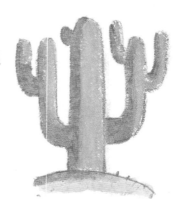

Do the same with the green wax crayon. Be careful when you outline the yellow colour.

Finish off by colouring the smallest areas. Draw with the crayon held at right-angles to the paper.

Colour the rest of the cactus light green, pressing lightly to avoid mixing the colour.

Blend the colours with your finger. Press a bit more on the shadowed areas until both colours melt together.

Draw with a graphite pencil or directly with a yellow ochre crayon.

First, apply two different values of yellow to the stem, trying to avoid mixing when you draw.

Like the other pictures in the book, this picture can be drawn larger than it is seen here.

First, colour the overall form with yellow crayon, being careful to leave the eyes white.

Draw the outline of the light yellow area with a red crayon and fill it in with the same colour.

Mix red and dark yellow. Draw the red with light strokes.

Apply yellow ochre lightly on the shadowed areas.

Mix them until both colours melt, and then add some stripes in dark brown.

First projects

Draw the outline and all the details - the eye, the ear and the shape of the legs. Also draw the edges of the shadows.

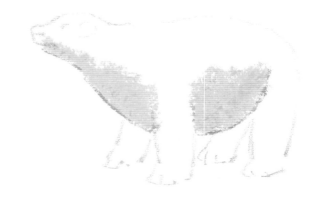

Apply yellow, using only a light pressure and slanting the crayon slightly.

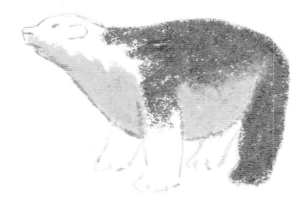

Do the same using the brown crayon. Draw with light strokes, all in the same direction, keeping the crayon at right angles to the paper.

Practise doing impasto. Rub, pressing your finger on the area that contains both colours, until they melt.

Draw the shape of the treetop and the branches, in as much detail as possible. This will help you when you colour them with the crayon.

Colour the foliage area with light yellow. It doesn't matter if you go over the pencil lines.

Colour all the rest with light green. Don't worry if some strokes mix into the yellow. Colour the trunk with a well-sharpened crayon.

Apply dark green with short strokes and, with your finger, make the impasto brown, and blend the green and yellow. Finally, colour the grass light green.

First projects

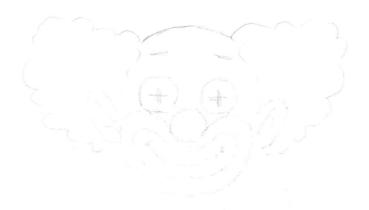

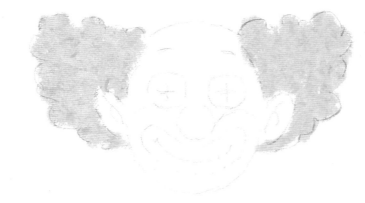

Copy this drawing. This picture will help you to practise one of the skills that has been explained on the previous pages: sgraffito.

Colour the clown's hair light yellow. Press lightly and be careful not to go outside the pencil lines.

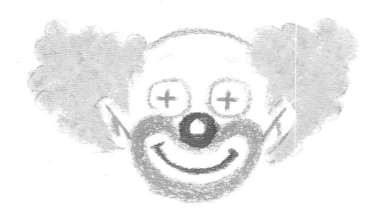

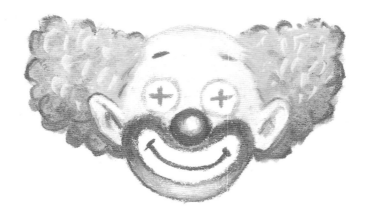

Draw two lines in light blue for the eyes and use red for the nose. Leave the highlight white. Apply pink, trying not to mix it with red.

Avoid the eyes when applying pink to the face, then use the white crayon to brighten them. Finally, apply sgraffito to the hair with the handle of a brush.

Draw the shape of the trees with a light green crayon or a pencil, trying not to press too hard. This will set the limits of the coloured areas.

Colour the top of the tree in the foreground with a green crayon, pressing it lightly. Do the same with blue for the meadows.

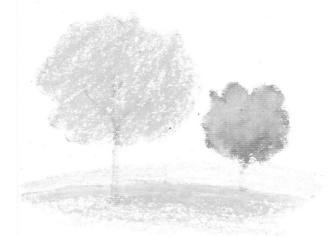

Apply a blue layer to the tree in the background and then add some strokes of dark green to form the shadows.

Colour the shadows on the tree in the foreground in the same way. Outline the trunks with dark brown and then add a few strokes of red. Finish off with yellow.

Advanced projects

Now you can practise several skills in drawing with wax crayons. Follow the step-by-step method shown on the next pages.

Before beginning:

○ Use a rag to clean your wax crayons of other colours and to clean your fingers

○ Clean any pigments that are left on the paper with a soft brush

One of the things about wax crayons is that they can be applied in a thick layer of colour. This helps you produce strong, bright pictures, but also means you need to use them very carefully.

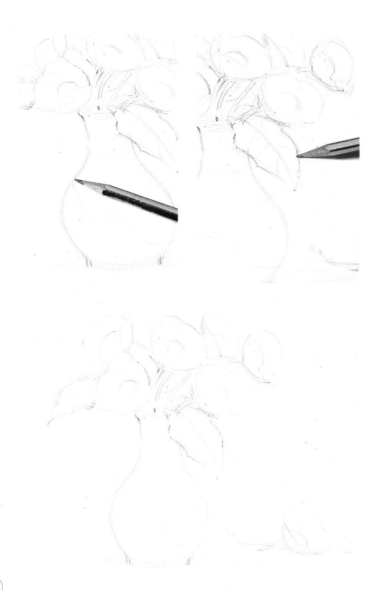

This picture helps you practise developing shades and colours by mixing the colours directly on the paper.

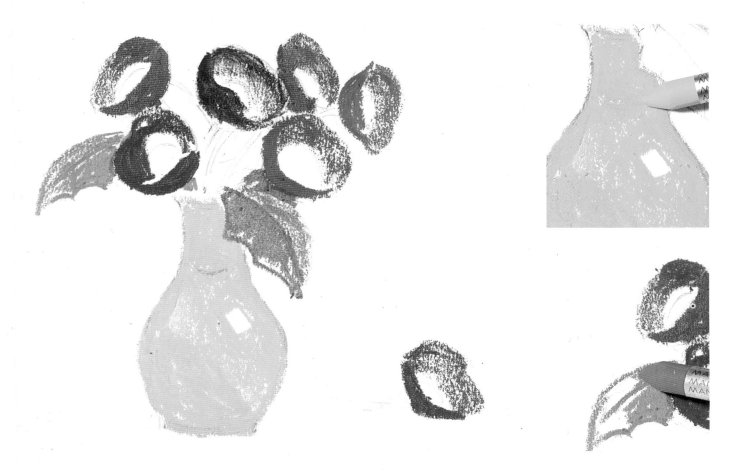

Apply a layer of yellow to the jar, keeping the crayon slightly slanted and making all the strokes in the same direction. Leave the highlights white. For the flowers, colour the lower areas with the crayon at right angles to the paper. Then hold the crayon in a nearly horizontal position to make the strokes on the upper areas. For the leaves, draw the outlines first and then fill them in.

Advanced projects

For the centres of the flowers, first draw the outlines with black crayon and then fill them in.

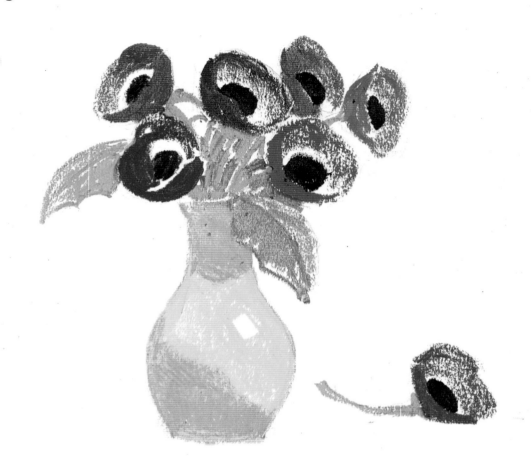

Colour the stems with short, hard strokes, switching between dark and light green.

Rub the yellow colour of the jar. Apply a layer of grey crayon.

For the flowers, first draw the outlines with a black crayon held at right angles to the paper, and then fill them in with the right colour.

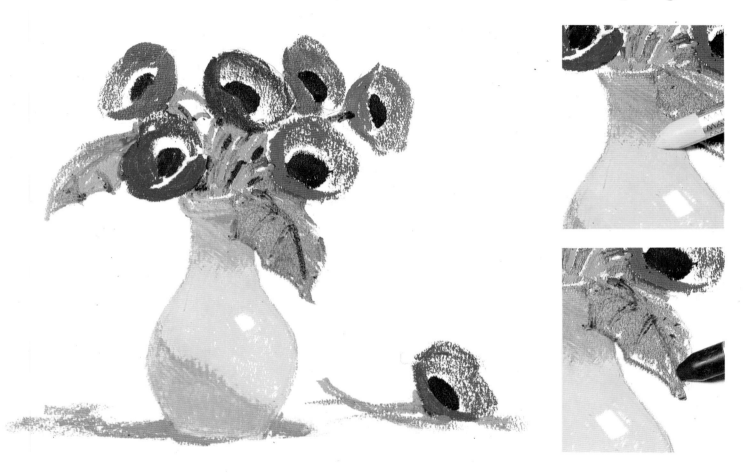

Now, on the jar, mix the yellow and grey with white crayon.

Using the grey crayon, add the shadow of the jar and the flowers.

Colour the leaves with several strokes in light green and fill in the empty areas of the stems with black crayon. Finally, draw the outline of the jar rim with grey crayon.

Advanced projects

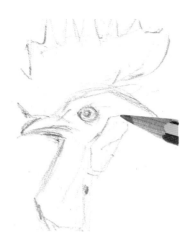

Draw with a semi-soft pencil, if you are not happy about drawing directly with crayons. Make sure you include all the details.

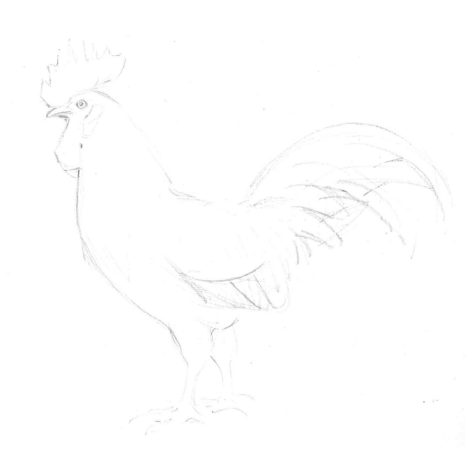

Many artists draw directly with a wax crayon in the colour that blends in best with the main colour of the picture. They do this because wax crayons will not cover the marks made by a pencil.

However, if you use a semi-soft pencil and avoid rubbing out too much, you can use a graphite pencil for these pictures.

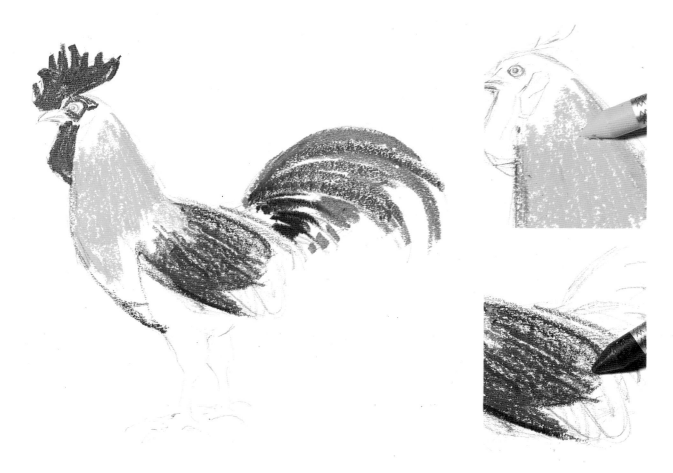

First apply a layer of light yellow and then colour the wings with dark brown.

Draw the beginning of the tail with a dark green crayon held at right-angles to the paper.

Use light green for the ends of the feathers with the crayon held almost horizontal to the paper.

Draw the comb with a red crayon, outlining it and then filling it in.

Advanced projects

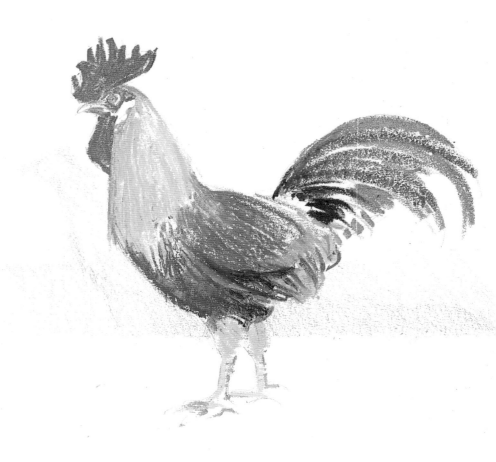

Carry on applying colour: yellow ochre for the lower part of the wings and light yellow for the feet. Mix red over the yellow ochre and rub the colours together with pressure. Streak the area between the neck and the wings with an orange crayon. Draw the outline of the beak with grey and fill it in with yellow. When you colour the background, use a piece of paper to mask the lower area.

Draw free-flowing strokes in white crayon at the roots of the feathers. This will give you a very bright effect.

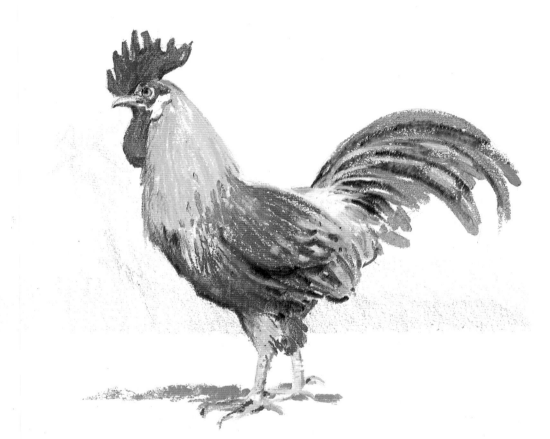

Draw the outline of the comb with red. Draw several strokes in red too; add some strokes in dark blue and then draw the outline of the beak. With a well-sharpened black crayon, draw the outline of the eye and the shadow of the beak. For the feathers, use a light green crayon held horizontal to the paper to make thick strokes. Colour the cockerel's shadow with the grey crayon held horizontal to the paper.

Advanced projects

It is important to draw the outlines of all the shapes in the landscape to mark the boundaries of all the colours.

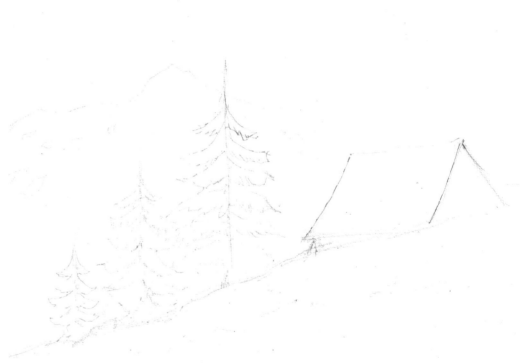

With this landscape, you can carry on practising the basic skills. You may continue developing different tones using the crayons with greater or lesser pressure, and mixing colours directly.

Draw the picture in as much detail as possible, but don't put too much pressure on the crayon. It is important to draw the outlines of all the shapes in the landscape to mark the boundaries of all the

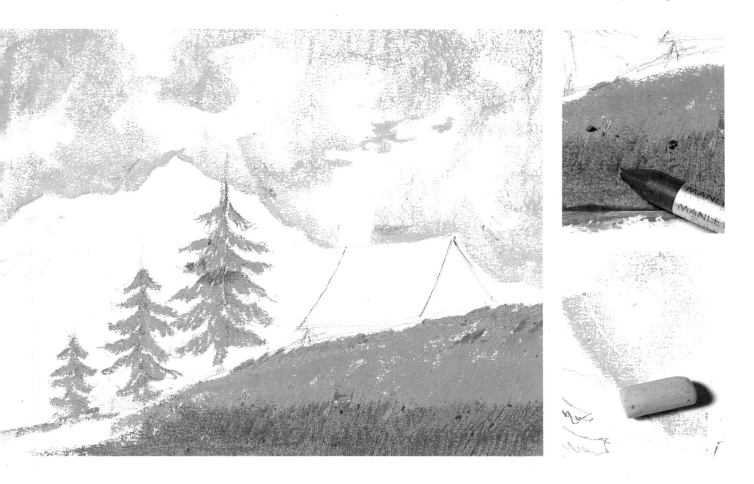

colours. Colour the sky light blue, keeping the crayon horizontal to the paper and pressing down in some spots to give the effect of clouds. With light green crayon, draw a line and colour in the paper below it with a dark green crayon held horizontally. Hold the crayon in a horizontal position to fill in large areas, and use it in an upright position to create strong tones.

Advanced projects

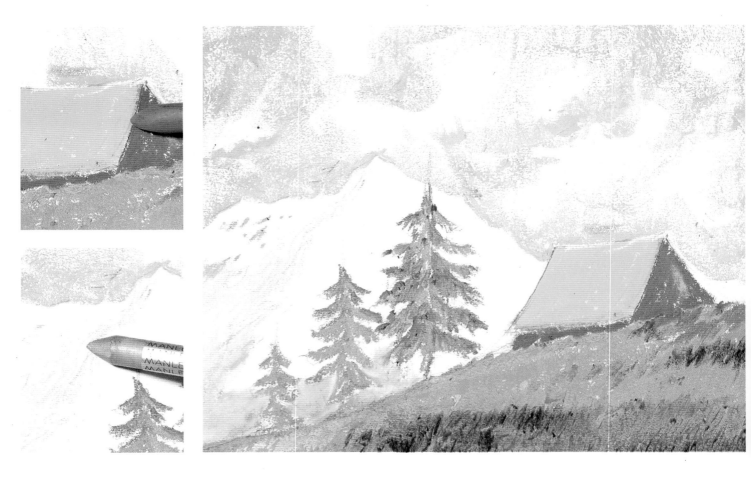

With the light yellow crayon, draw some vertical strokes on the left side of the meadow and then lightly add some light green.

Colour the tent top light yellow and the entrance shadow and lower side in yellow ochre. Add some dark green strokes for the trees. Colour the mountain grey; then whiten it a bit.

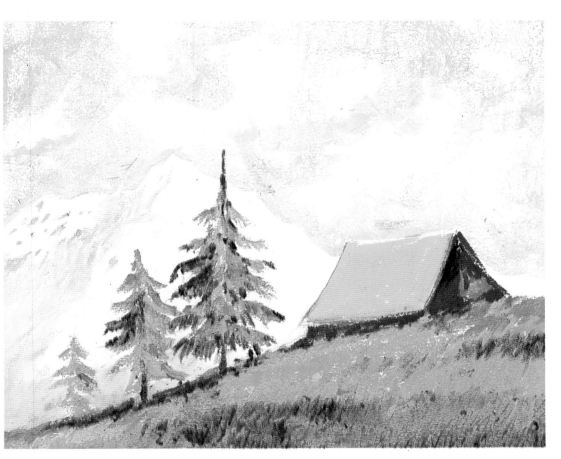

Colour the middle-distance areas between the trees with a few red and brown strokes. This will create warm colour contrasts.

Apply red to the entrance of the tent. Add some strokes of black crayon and mix both colours.

Also colour some areas between the trees red.

Add grey to the mountain and whiten it.

Add dark green to the trees, emphasizing the outline of the leaves.

Advanced projects

Blend all the different shades of green in the meadow by colouring lightly with a yellow crayon.

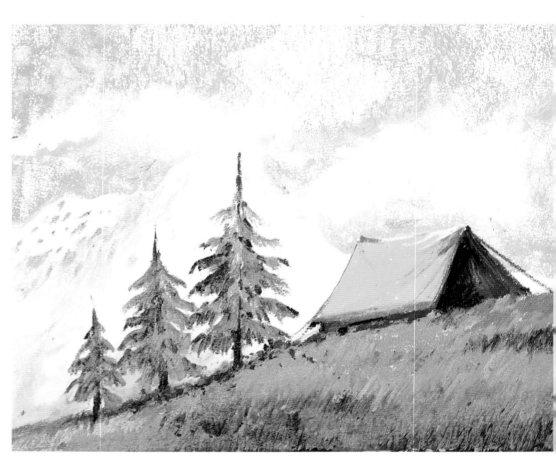

Draw the creases in the top of the tent with yellow ochre and draw the outline of the entrance. Apply red crayon.

Draw the trunks of the trees dark brown and the branches green. Create highlights at the tips, outlining the branches with light green.

A few strokes in red will add contrast to the main green colour of the grass.

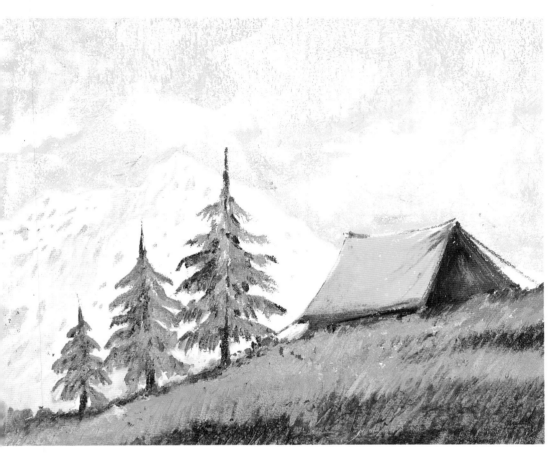

Apply colour to the lower left-hand corner of the tent, pressing lightly with the crayon.

Blend the colour with your fingertips. Add a few last details and your landscape will be finished - a few strokes in dark green on the branches, a stressed red colour between the trees, and blend the grey of the mountain with white crayon.

Advanced projects

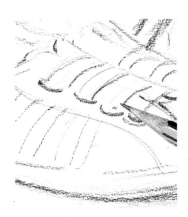

First, use a pencil to make a detailed drawing. This will form the basis for your wax crayon picture.

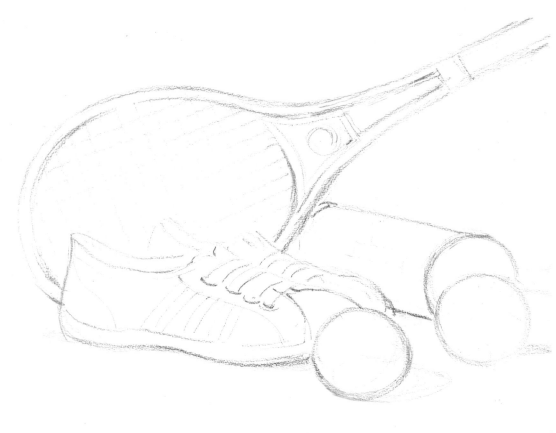

This still life will use all the skills you have learned. It is not difficult but it will give you an idea of the possibilities for using wax crayons in future.

This is a chance to practise the skills of impasto and sgraffito. Start by making a detailed drawing and then just concentrate on the colour.

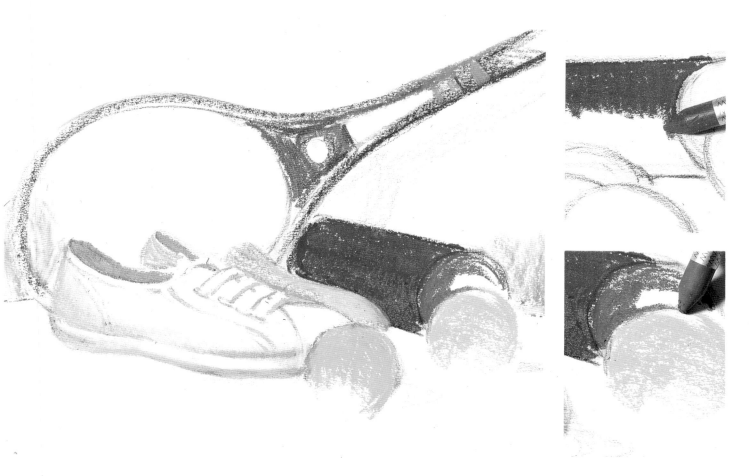

Draw the outline of the tennis shoes with grey. Add green. Apply a first layer of colour on half of the tennis-ball tin. Colour the rim deep blue and the rest red. Draw the shape of the racket in brown and sketch the shadow in grey. Colour the background, holding the crayon horizontal to the paper. Do the impasto of the background shoe in white.

41

Advanced projects

Carefully blend your colours to give a shading effect on the ball.

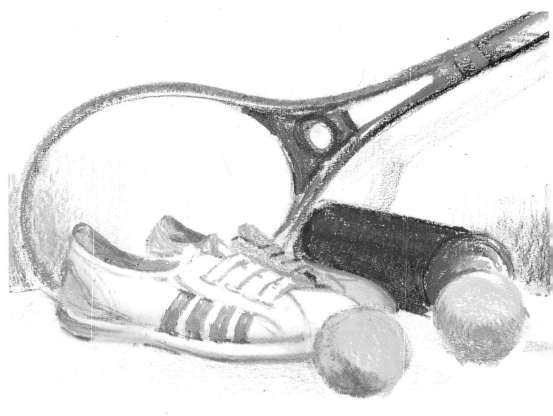

Apply yellow ochre to the lower area of the tennis ball and blend with light green on the area in the middle distance.

Apply a soft shaded background with the orange

crayon on the heel of the tennis shoe. Colour the shoe's shadow grey.

Add some brown strokes to the background shoe and draw the outline of the racket in light blue.

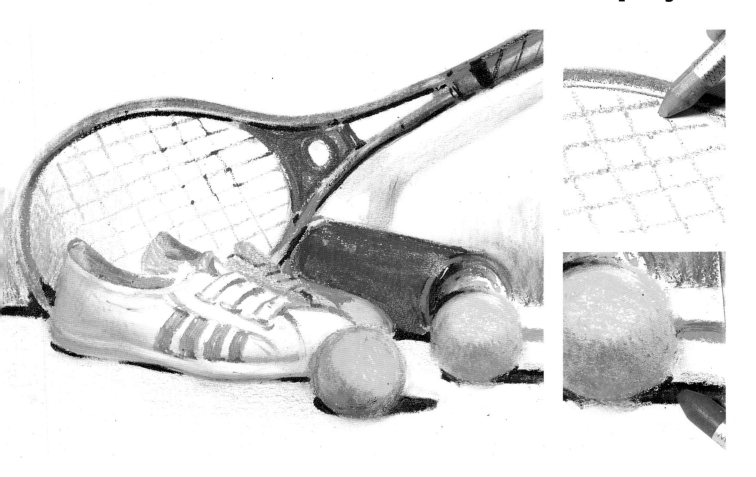

Colour the strings of the racket grey. Apply the crayon very carefully, using short, irregular strokes.

Make an impasto of the right-hand background and rub the green colour on the ball with your finger until it blends with the yellow ochre and the yellow.

Develop the shadows of the ball with grey and black. Make an impasto on the lower area. Add some red to the shadow.

Advanced projects

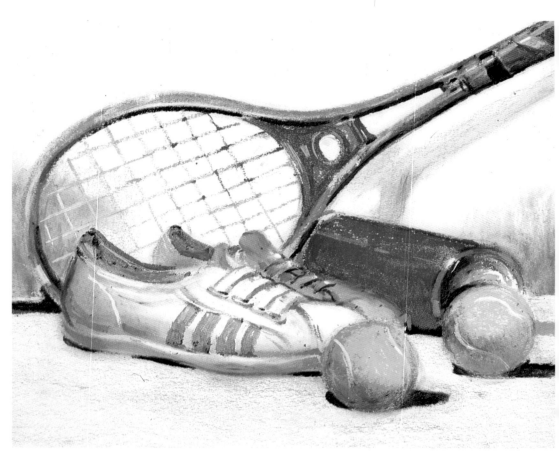

Do the sgraffito on the left side of the strings.

The result will depend on the thickness of the layer of wax. Do the sgraffito on the shoe and the tennis balls as well.

Colour the racket handle brown and then mix in some yellow ochre and a few strokes of red.

Finally, add some highlights with white crayon.

Use your finger to blend the purple and red on the side of of the can.

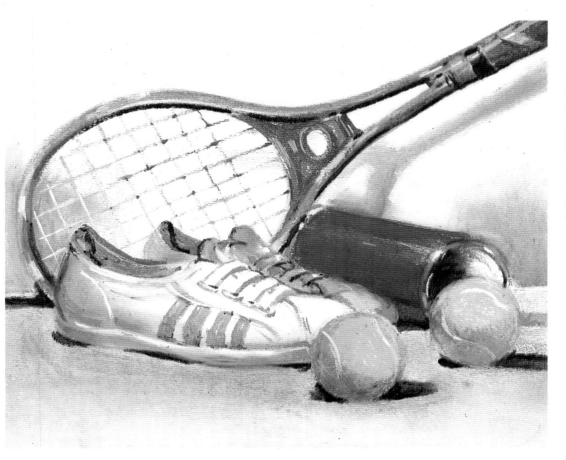

Add red to the lower part of the ball container and then mix purple and red again. Do the impasto and add some pink.

Use grey for the shadow of the shoe. Do the impasto with your finger.

Finally, whiten the lower area and emphasize the shadow of the raquet with grey.

Glossary

blend. To mix two or more colours. In the case of wax crayons, this usually involves rubbing them with the fingers.

colour wheel. A circle made up of twelve colours: three primary colours, three secondary colours and six tertiary colours. Another name for colour wheel is chromatic circle.

complementary colours. The secondary colour created by mixing two primary colours, which is said to be complementary to the third primary colour (for example, green, created by mixing blue and yellow, is complementary to red).

composition. The arrangement of all elements of a subject in a pleasing way.

cool colours. The colours in the colour wheel between green and violet, with both these colours included.

harmonize. Set down colours so that none clashes with the others.

impasto. The technique of applying colour like paste. When using wax crayons, rubbing layers of colour with the fingers creates a paste-like substance.

perspective. Drawing rules for creating on paper, which has only two dimensions (length and width), the impression of the third dimension (that is, depth).

pigment. A coloured powder made from earth, finely ground stones, vegetables, chemicals, etc, which is mixed with a medium such as oil to make paints, or with wax to make crayons.

primary colours. Red, blue and yellow; the colours that are blended to produce other colours, but that cannot themselves be created by mixing.

scale. A group of all the tone variations in a colour.

secondary colours. Orange, purple, and green; the colours created by blending pairs of primary colours.

sgraffito. The technique of scratching through the crayon to expose the white surface underneath.

shading. Capturing light and shadows by changing a colour through different tones.

sketch. A rough drawing or painting in which the shape, composition, and tonal values of light and shadows are shown.

still life. A drawing or painting based on a collection of objects arranged in a particular way by the artist.

tertiary colours. The colours created by blending a primary and secondary colour (for example, blue-green or red-orange.)

tone. Intensities of a colour, from the lightest to the darkest.

value. The degree of lightness or darkness of a colour. A weak value is very light (or pale); a strong value is dark and intense.

warm colours. The colours in the colour wheel between crimson and light yellow, with both these colours included.